Donald Baechler

Essay by Phoebe Hoban

Cheim & Read
2017

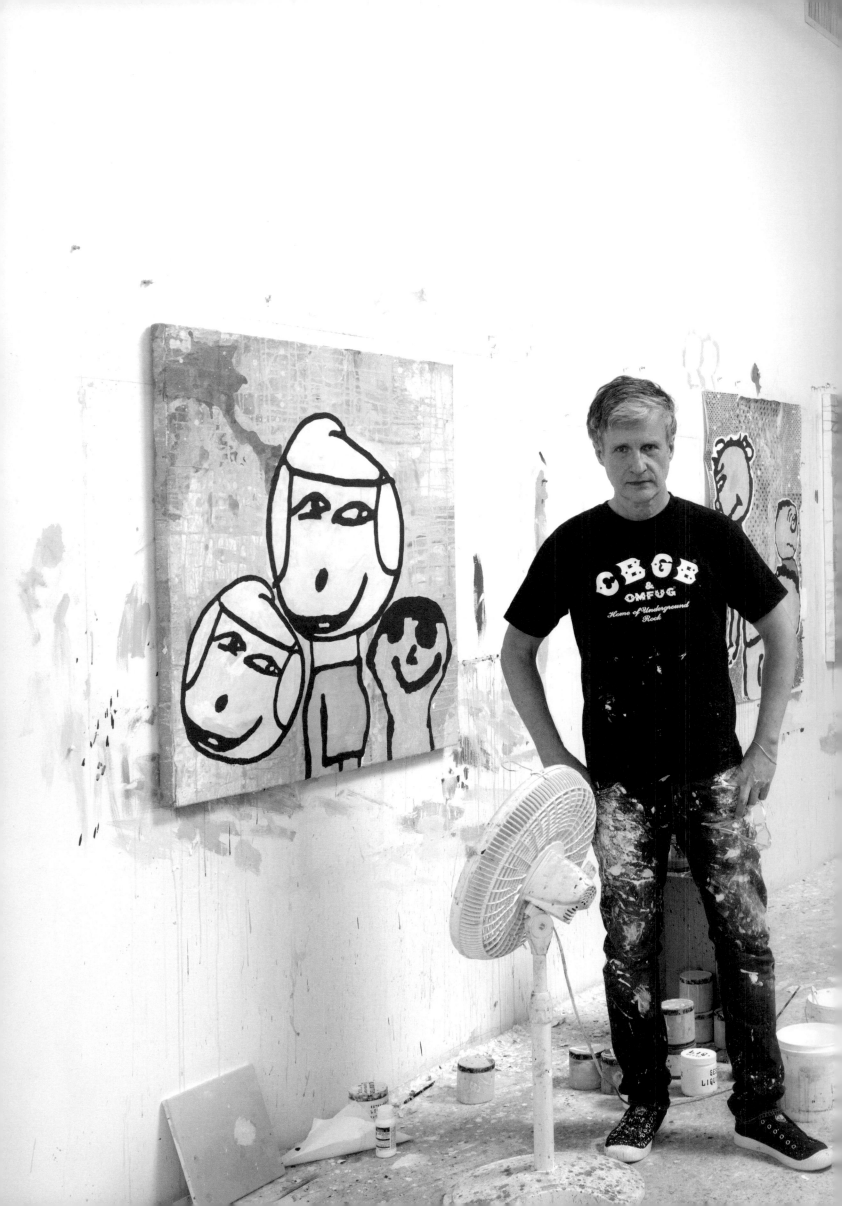

Donald Baechler: Childhood's Edge
Phoebe Hoban

Donald Baechler's art has often been called faux-naïf. But faux-noir
might be the more appropriate description. Baechler floats found
images, from textbook drawings to rose tattoos—as well as his own fluid
doodles—against a collaged background. The images themselves couldn't
be much more basic, their coloring-book-like thick, black outlines
sometimes colored in, sometimes not. These simple yet evocative graphics
are juxtaposed against a complex background composed of a rich abstract
palimpsest of colors and textures, ranging from stained muslin to quilting
squares to bits of Italian tablecloths, both anchoring the images and
unfurling them into a deeper dimension.

 The contrast of the extreme flatness of the simple central image and
the complicated pleated or quilted background is aesthetically pleasing—
but somehow subtly disquieting. It's as if the viewer were being posed the
question: "What's wrong (or right) with this picture?"

 Baechler grew up in suburban Connecticut, after his family moved
from inner-city Hartford when he was in second grade. His father was
a state accountant, and his mother was a journalist for the local paper.
There was no art in the house, but the ornate details of their first home,
in Hartford—the beautiful moldings, doorknobs and hinges—and their
contrast with the "brand new tiny suburban ranch house" made a deep
impression on him. "My whole aesthetic process of looking at something
and valuing it began when I was about seven," he says. From the time
he was young, Baechler wanted to be an artist, not just any artist, but "a
rich and famous one, a term I had heard probably without even knowing
what it meant."

The family were Quakers and each Sunday afternoon after the meeting, they would stop at the Hartford Public Library or the Wadsworth Atheneum Museum, where Baechler fell in love with works by Robert Rauschenberg, Andy Warhol, Jasper Johns, Barnett Newman and Sol LeWitt. He also fell in love with archives, and began accumulating his own extensive library of images, scavenged from flea markets and country auctions.

At 16, he worked for the summer as a janitor at the museum, and although in the 1970s he attended the Maryland Institute College of Art and the Cooper Union, his art education really began that summer. "I worked all the shifts nobody else wanted, and I was alone with the paintings and I had this constant fantasy of working on top of other paintings," he recalls. In particular, "There was a Larry Poons that I wanted to paint on top of. That abandoned, elegant, rubbery work seemed like it was crying to have something stuck in the middle of it. I had this desire to create something that would intervene with the background of this painting." The Baechler aesthetic was born.

As he observes, "My work to a certain extent is absolutely about other pictures, the world of existing imagery." Baechler's process has varied slightly over the years, but the basic steps remain the same. Like most painters, he begins with the background. But in his case, it is never a blank canvas. "I can't even imagine that. I love gluing things together. It is a deeply satisfying process, and it is a very different impulse than just making a drawing. It becomes a kind of sculptural thing," he says, citing Rauchenberg's combines as a huge influence. Baechler constantly creates backgrounds that stack up in his studio, "percolating" as much as several years before they are at some point "cooked," and ready to be painted on. "I have a need for there to be a resolved compositional system that has something imposed on it, that disrupts or defaces it," he says.

Inspired in part by the multitude of quilting ingredients he inherited from his mother, a "frustrated quilter," Baechler's backgrounds consist of layering many different materials. "She left behind enormous boxes and bins of fabric, and that's where I found the backgrounds for my collages, and then that led to other things, like looking for lace at flea markets," he says. Having long since exhausted that material, Baechler now makes his own, including stained muslin and silk-screened prints. The carefully composed background usually gets yet another layer — "rips and drips and actions and normal studio kinds of stuff," the artist says.

Baechler's central, superimposed imagery, the emblematic flowers and figures, come both from his vast library and his own supply of constantly-created drawings. The choice of which image is painted on which background is purely spontaneous. One often-repeated emblem, a rose, derives not from nature, but from photographs of actual rose tattoos Baechler has taken over the years. His other flowers also derive from decorative arts, like wallpaper and china. Children's textbooks are another source, as are children's drawings. "I sometimes have a group of children in my studio who make drawings of my drawings which I then redraw to use in my paintings. I love the circularity of it."

Baechler's current batch of work, particularly *Severed Shadow* (plate 5) seems to pointedly reflect the current fraught political times. But in fact, the artist says, that was not his intention. *Severed Shadow* is actually a portrait of his close friend, who has paranoid fantasies of being arrested and had recently dyed his hair blond. Like many of his new paintings, all from 2017, the background is almost flat and somewhat decorative, incorporating much less relief than his past work.

Like several of the other paintings depicting figures, the image in this one has his back facing towards the viewer, a favorite pose of the artist; a nod towards both the Hudson River School and the artist Caspar David

Friedrich, which Baechler uses to indicate "something, a landscape," beyond the frame. "It is a very compelling pose. I find myself drawing from three-quarters behind, rather than the front, so that the figure is looking at something you can't see."

That is especially evoked in *View* (plate 1), a partial image of a seated woman in a striped shirt. She is gazing at something invisible to the viewer, a lovely ephemera expressed by the collaged squares, with their delicate markings and drips. In *The Ordinary Song* (plate 10), the image of a man, derived from a Portuguese language textbook, is striding off into nowhere. This painting has by far the most complex background in the series, an extraordinary array of pleated and quilted textures. Arranged in a pale palette embellished with painted lines and marks, it looks like a stand-alone abstract painting. Part of the pleasure of Baechler's work is seeing the artist's hand, clearly evident here. The background also creates a depth of field, and provides the central figure with "the extra room" that Baechler thought it needed.

Gertrude Stein's famous quote, "a rose is a rose is a rose," applies neatly to Baechler's rose-tattoo paintings, such as *The In-Laws of Experts #3* and *Mystery of Mastery* (plates 16 and 4), both of which have a pretty, pastel-like, nearly-flat abstract background vaguely reminiscent of Warhol's silk-screened flowers. Baechler's flower images can be loaded; they evoke beauty and the feminine; at the same time they may subtly suggest the artist's orientation and his fascination from childhood on with adornment and ornamentation.

Both *The Hard Double* (plate 15) and *The Kiss* (plate 13) perfectly capture Baechler's faux-noir tendencies. The *South-Park*-like figure of the character sprouting two heads is childlike and humorous, and at the same time disturbing. Referencing his *Crowd* paintings of the 1990s, which also sported multiple noggins, the character seems to at the very least have a

split personality. And in *The Kiss*, the girl is grinning, but the expression on the boy's face is more like a grimace.

Like his peers, Keith Haring and Jean-Michel Basquiat, Baechler has created his own iconography and vocabulary. His work bears several similarities with Basquiat's, and both owe a heavy debt to Cy Twombly, with his intensely literate drawing and Jean Dubuffet, with his Art Brut. Like Basquiat, Baechler has a fondness for skulls. He typically superimposes emblems and figures onto complicated backgrounds — in his case the tactile complexity of collaged materials, in Basquiat's case the complexity of language and found poetry. Both Baechler and Basquiat have an innate sense of composition, and are able to synthesize apparently random images into paintings whose consistently childlike aspect belies their elegant sophistication.

1. View 2017 acrylic and fabric collage on canvas 60 x 60 in 152.4 x 152.4 cm

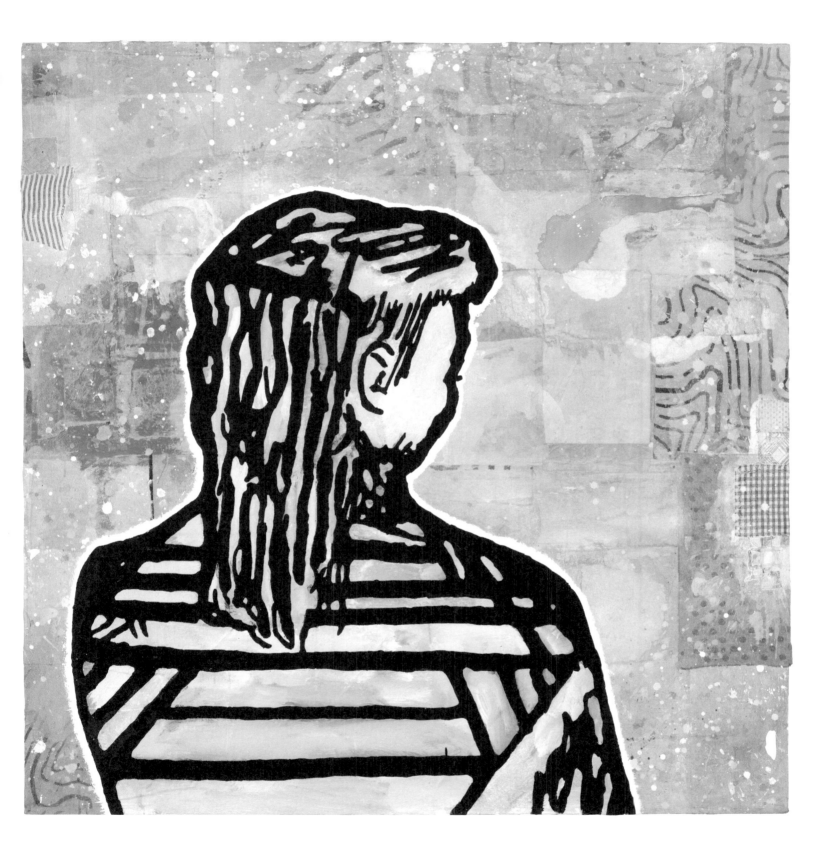

2. The Serious Season (Red + Blue) 2017 acrylic and fabric collage on canvas 60 x 60 in 152.4 x 152.4 cm

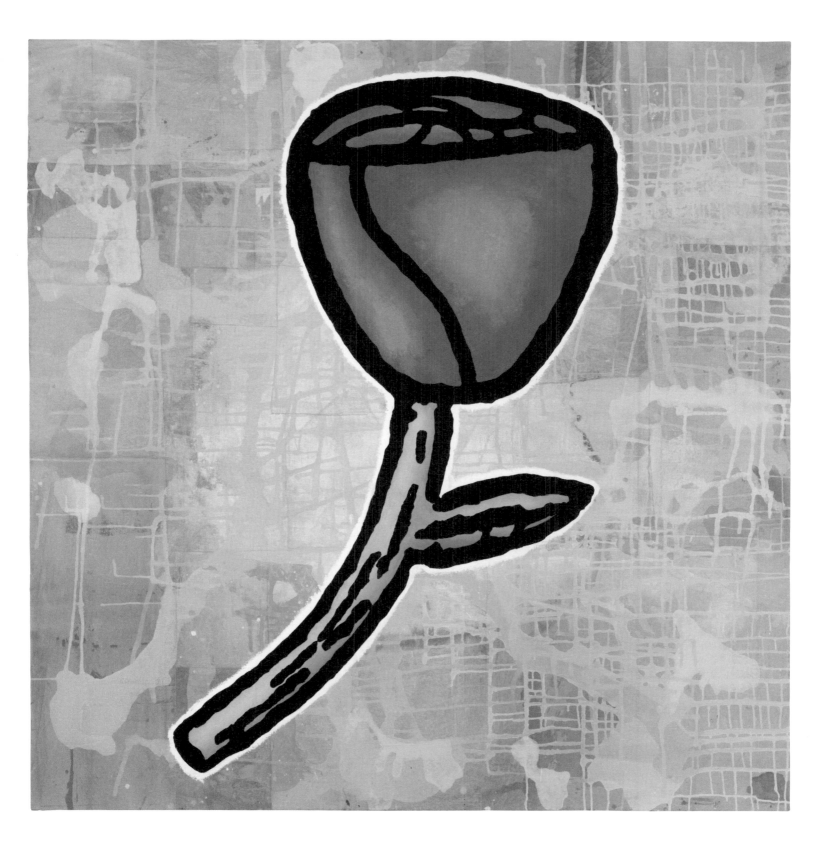

3. Protest of Predictor 2017 gesso, flashe and paper collage on paper 46 x 36 in 116.8 x 91.4 cm

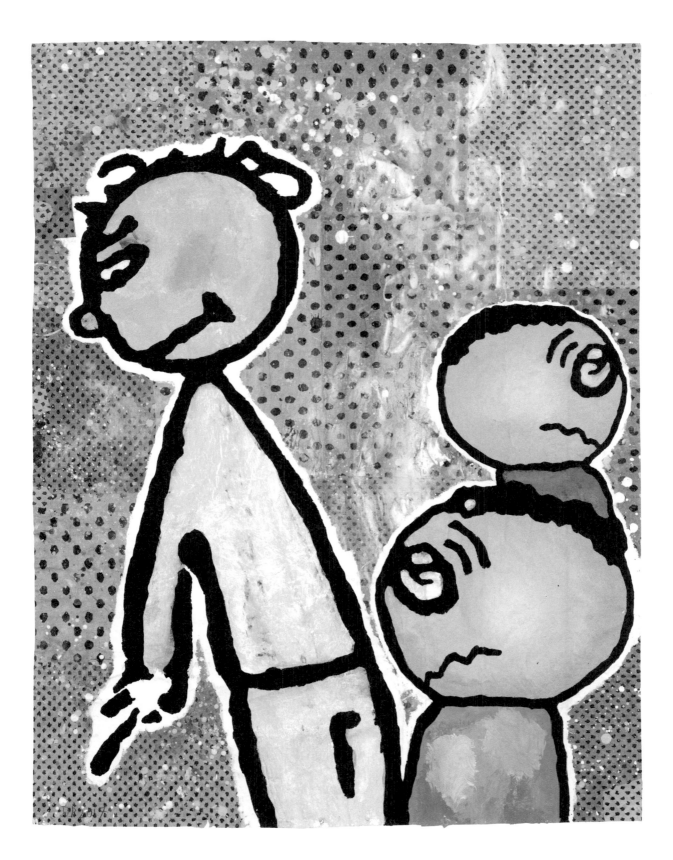

4. Mystery of Mastery 2017 acrylic and fabric collage on canvas 36 x 36 in 91.4 x 91.4 cm

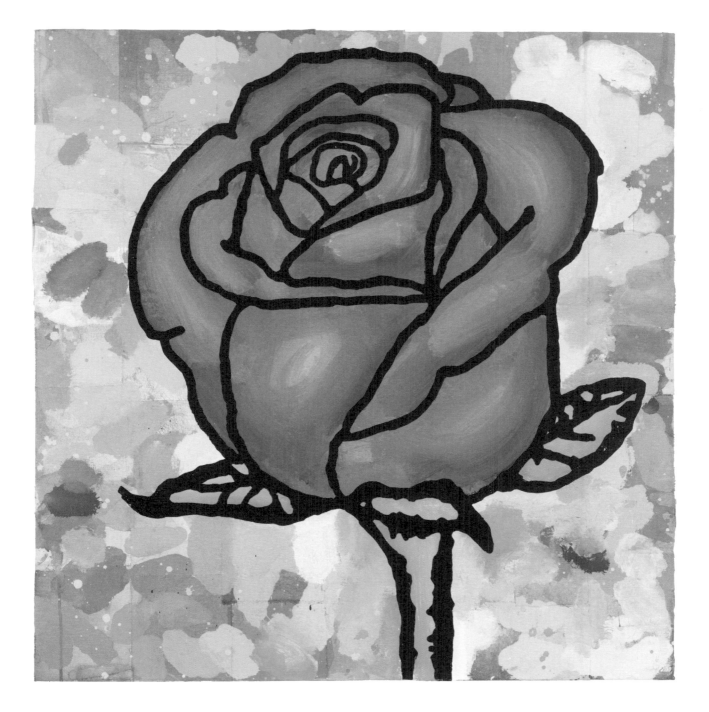

5. Severed Shadow 2017 acrylic and fabric collage on canvas 40 x 40 in 101.6 x 101.6 cm

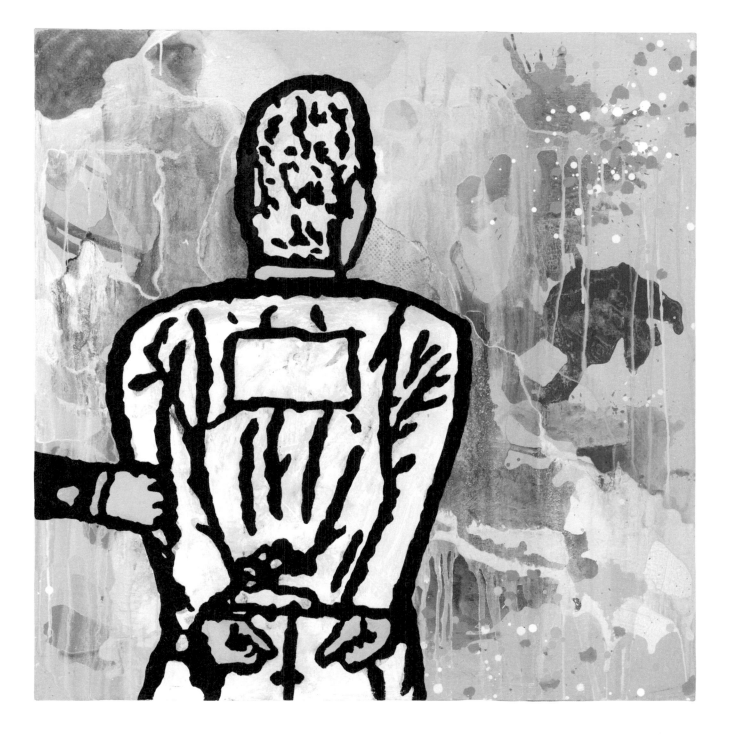

6. The Odor of Earaches 2017 acrylic and fabric collage on jute 40 x 40 in 101.6 x 101.6 cm

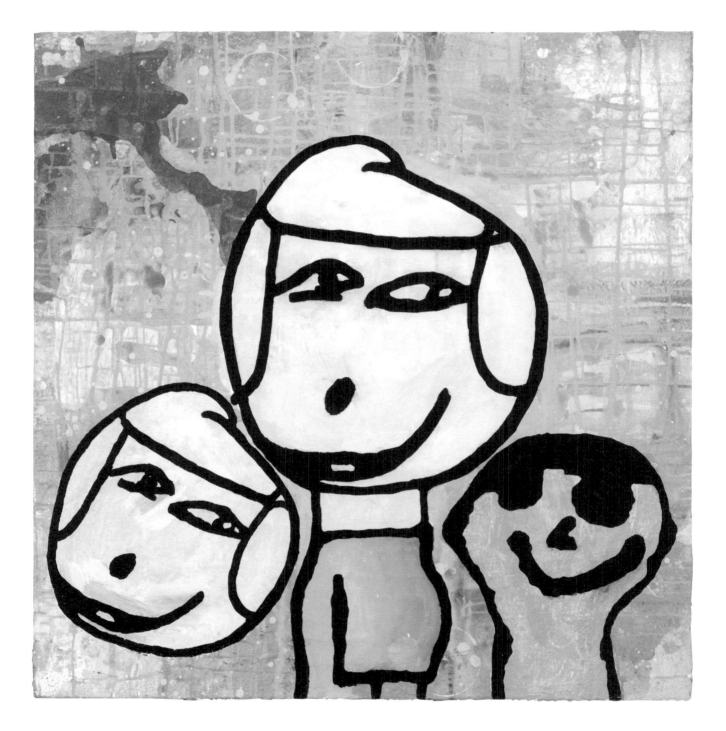

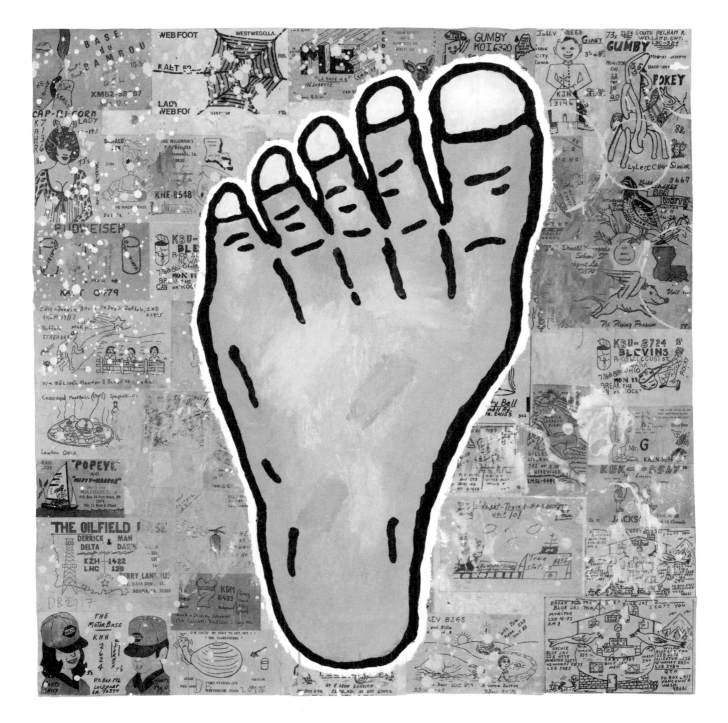

8. Overture of Elves 2017 acrylic and fabric collage on canvas 72 x 48 in 182.9 x 121.9 cm

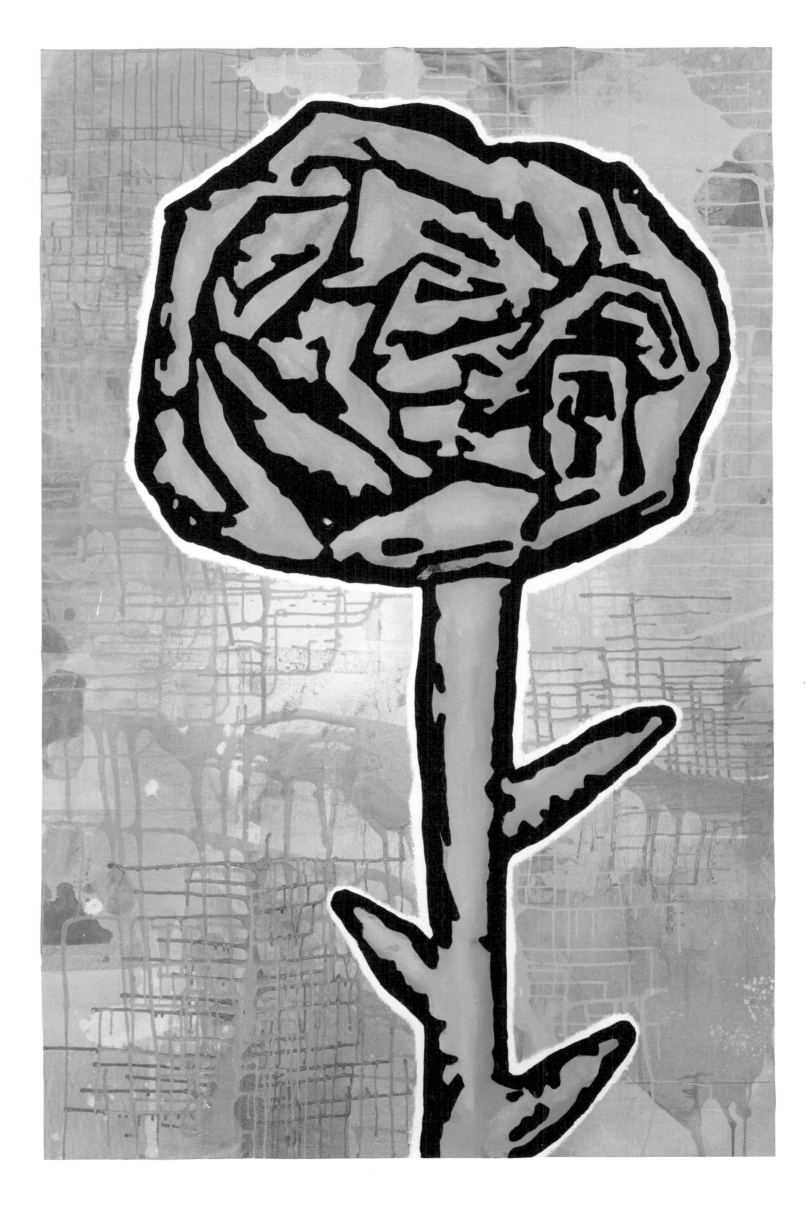

9. Vitamin of Experience 2017 gesso, flashe and paper collage on paper 52 x 40 in 132.1 x 101.6 cm

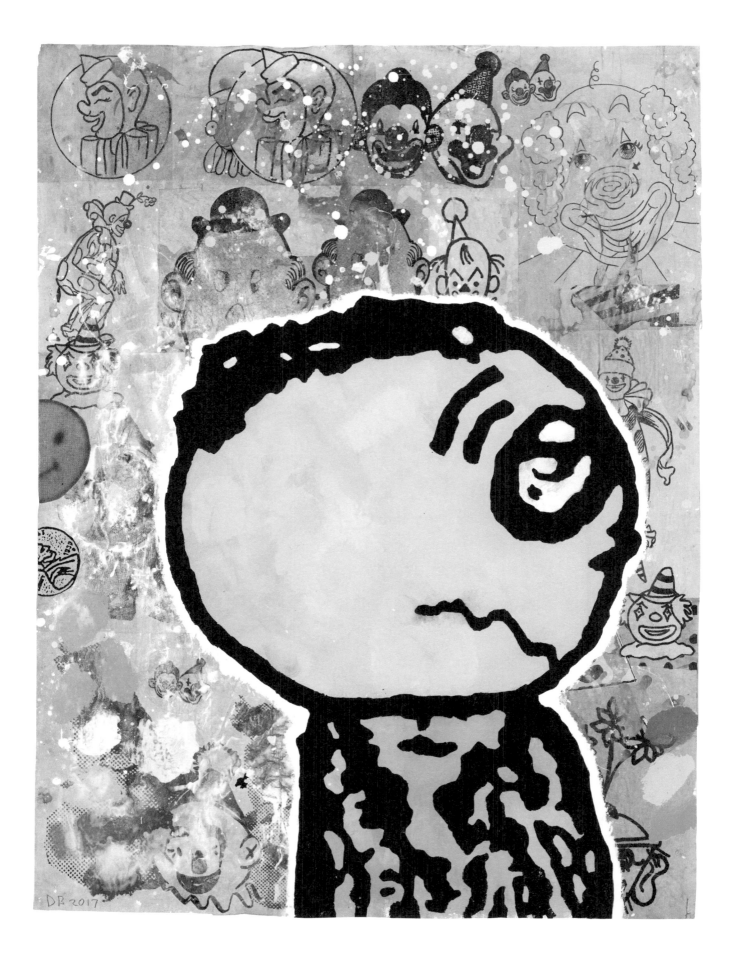

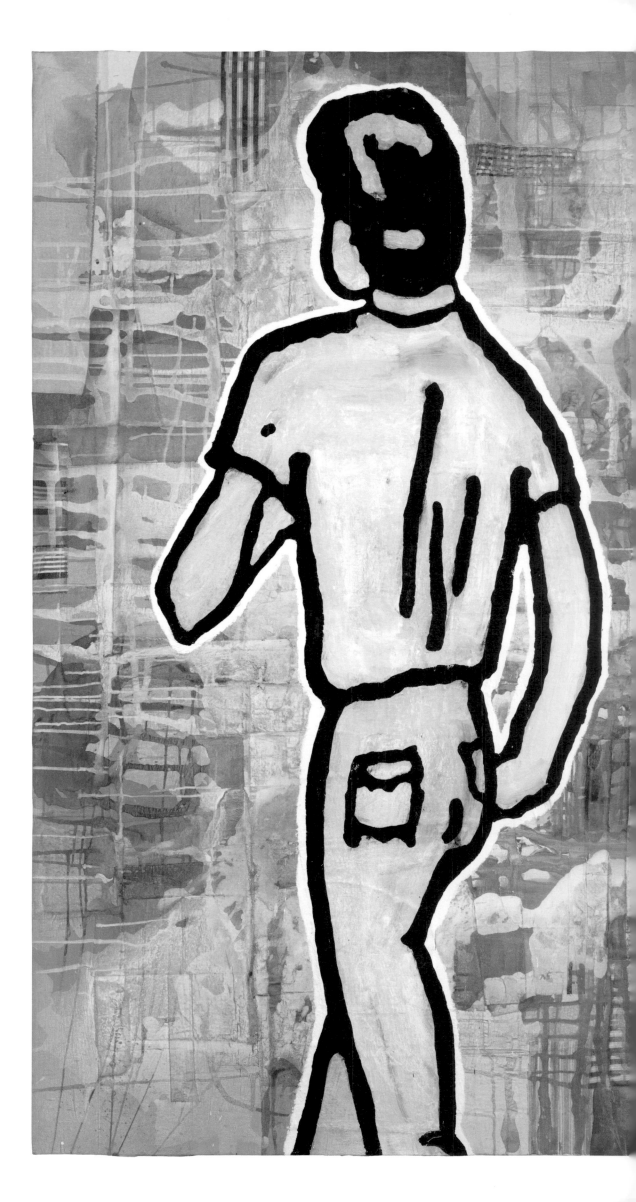

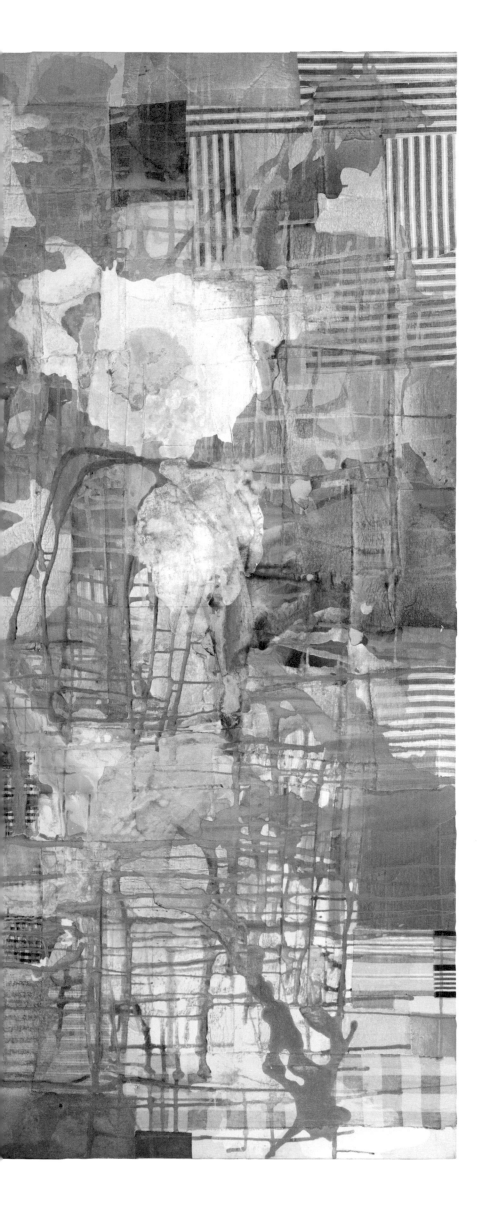

10. The Ordinary Song 2017
acrylic and fabric collage on canvas
80 x 80 in 203.2 x 203.2 cm

11. Head 2017 acrylic and fabric collage on canvas 40 x 40 in 101.6 x 101.6 cm

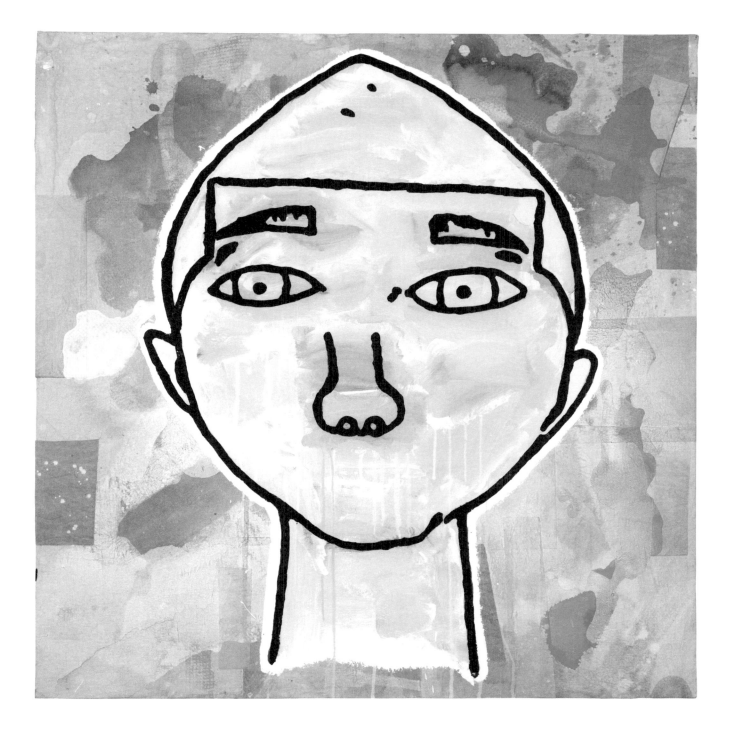

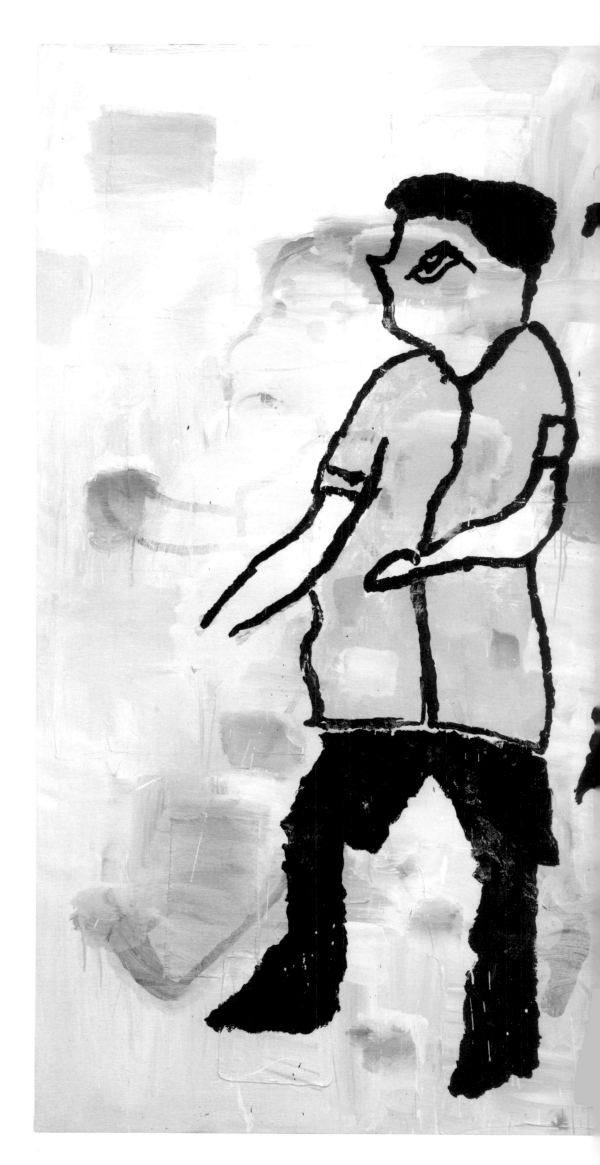

12. Procession #2 2017 acrylic
and fabric collage on canvas
111 x 143 in 281.9 x 363.2 cm

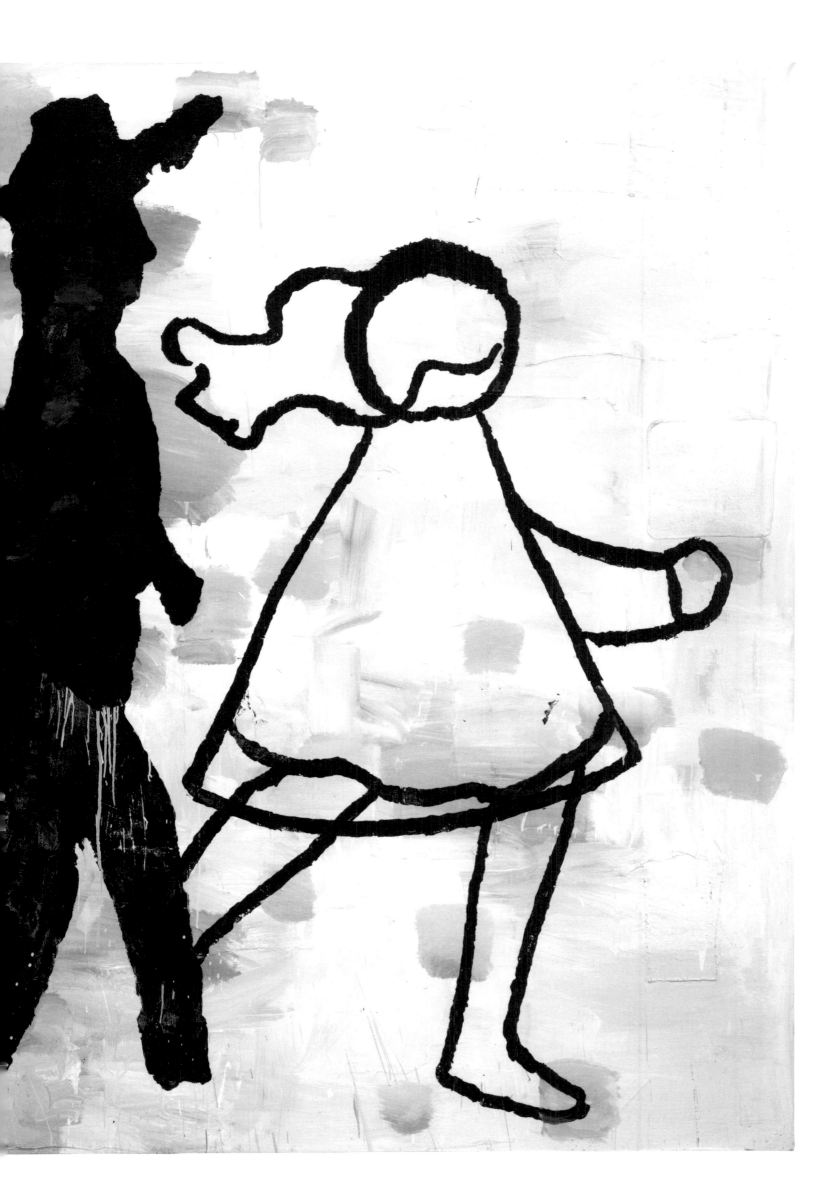

13. The Kiss 2017 acrylic and fabric collage on canvas 40 x 30 in 101.6 x 76.2 cm

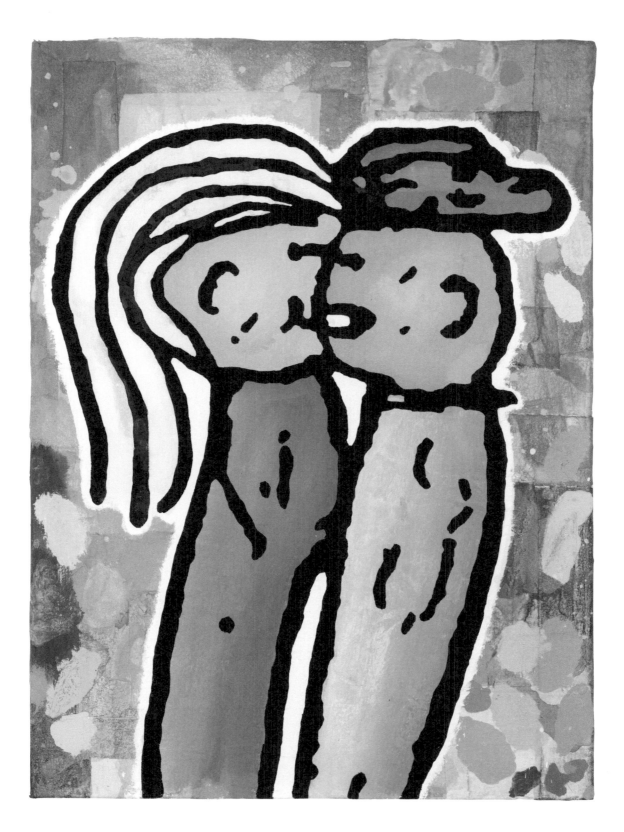

14. Cold Window 2017 acrylic and fabric collage on canvas 36 x 36 in 91.4 x 91.4 cm

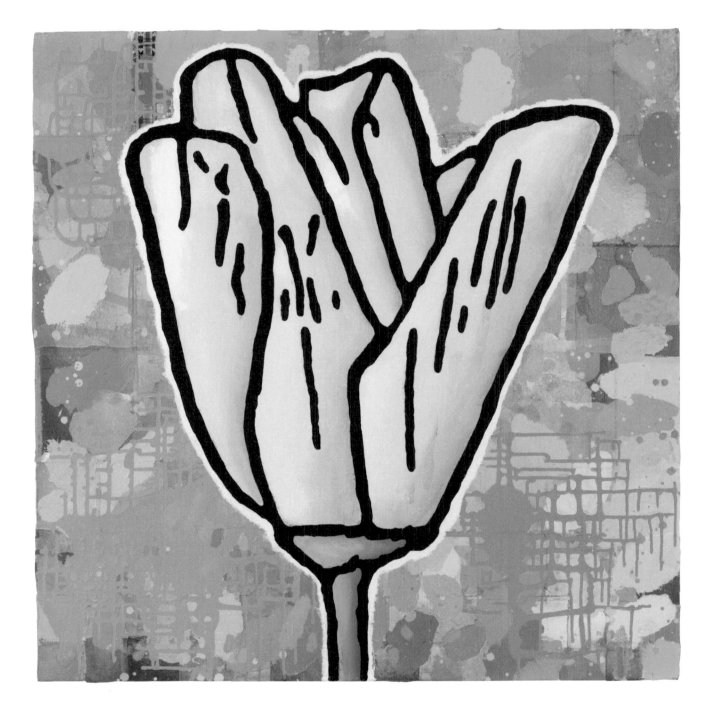

15. The Hard Double 2017 acrylic and fabric collage on canvas 45 x 30 in 114.3 x 76.2 cm

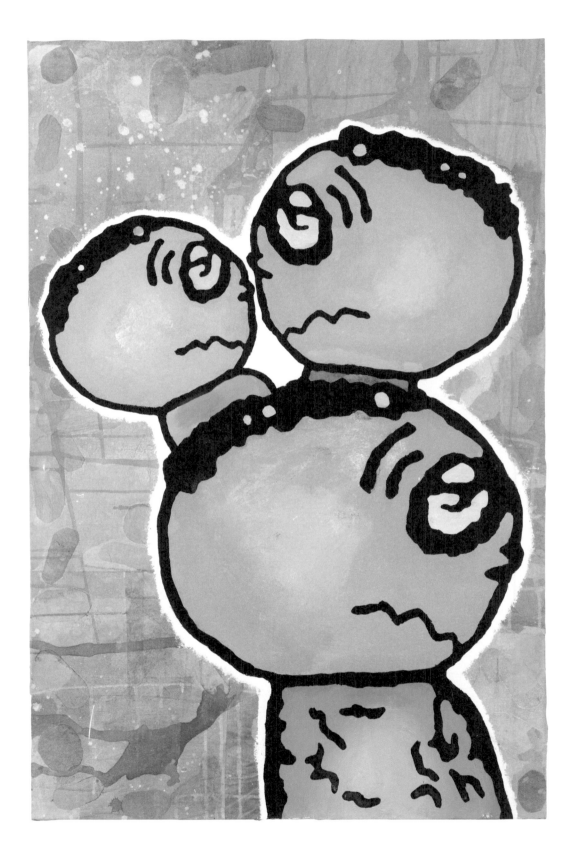

16. The In-Laws of Experts 2017 acrylic and fabric collage on canvas 36 x 36 in 91.4 x 91.4 cm

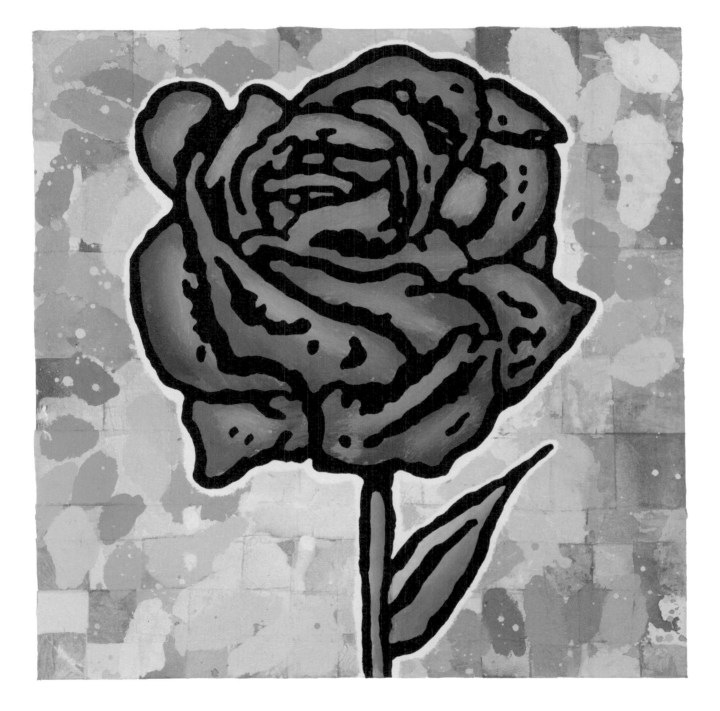

17. The Infant of Advocates 2017 gesso, flashe and paper collage on paper 52 x 40 in 132.1 x 101.6 cm

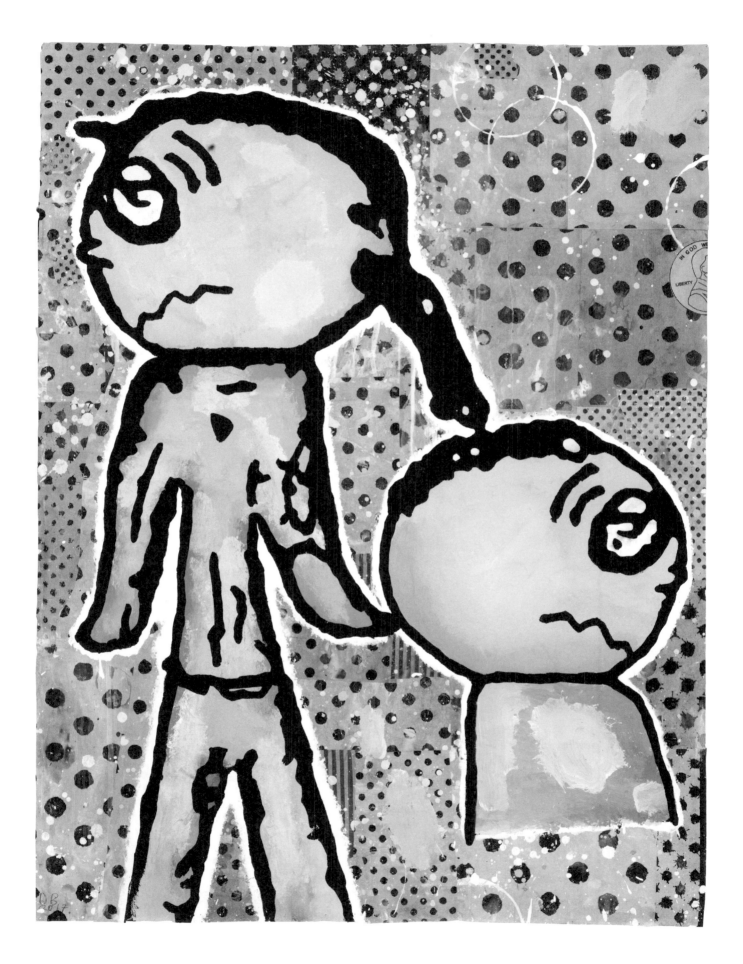

BIOGRAPHY

Donald Baechler was born in Hartford, Connecticut, in 1956. He attended the Maryland Institute College of Art, Baltimore (1974–77) and Cooper Union, New York (1977–78). In 1978–79, he spent a year studying at the Städelschule, Staatliche Hochscule für Bildende Künste, Frankfurt. While in Germany he became acquainted with Jiri Georg Dokoupil and Walter Dahn. He has traveled widely, including such places as Tangiers, Burma, Cambodia. Vietnam, Thailand, India and Indonesia, whose culture and street life have influenced his art.

Critically, Baechler has been linked to the Neo-Expressionist generation of painters, but he was also deeply influenced by the Conceptual artist Joseph Kosuth, and he has listed Cy Twombly, Giotto, and Robert Rauschenberg as the three artists who are most important to his thinking.

Baechler's work is represented in collections including: Museum of Modern Art; Whitney Museum of American Art; and Solomon R. Guggenheim Museum, all in New York; Museum of Contemporary Art, Los Angeles; Museum of Fine Arts, Boston; Philadelphia Museum of Art; and Centre George Pompidou, Musée National d'Art Moderne, Paris.

Design John Cheim

Essay Phoebe Hoban

Editor Ellen Robinson

Published on the occasion of the Cheim & Read exhibition
November 2 to December 23, 2017

Photography Brian Buckley
Printer GHP Media
ISBN 978–1–944316–09–9